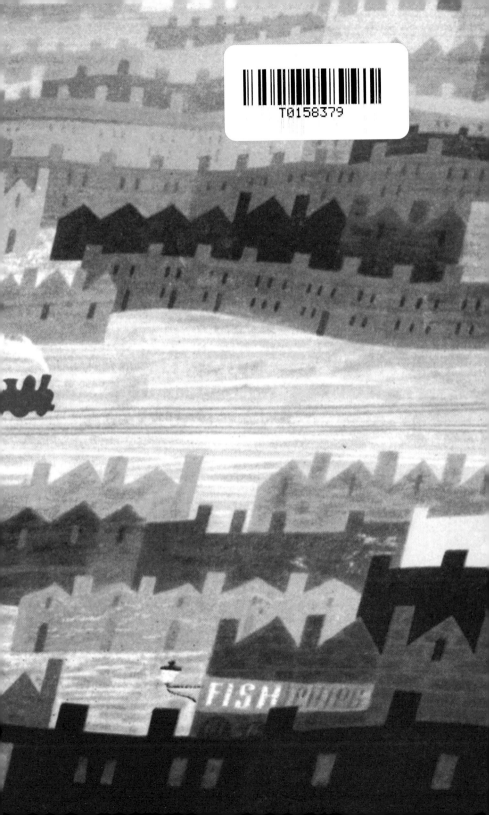

Ruth Artmonsky

Jan Le Witt and George Him

DESIGN

Lewitt-Him

Antique Collectors' Club

British Library Cataloguing-in-Publication Data
A catalogue record for this book is available from the British Library

Antique Collectors' Club
www.antiquecollectorsclub.com

Sandy Lane, Old Martlesham
Wodbridge, Suffolk IP12 4SD, UK
Tel: 01394 389950 Fax: 01394 389999
Email: info@antique-acc.com
or
Eastworks, 116 Pleasant Street - Suite 18
Easthampton, MA 01027, USA
Tel: (413) 529 0861 Fax: (413) 529 0862
Email: sales@antiquecc.com

Published in England by the Antique Collectors' Club Ltd.,
Woodbridge, Suffolk
Printed and bound in China

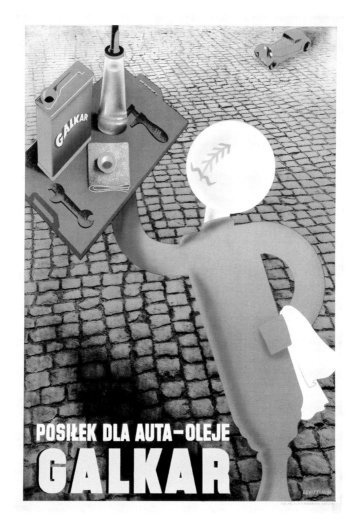

1934. 'Food for Cars'. Poster for Galkar Oils, a Polish industrial oil manufacturer.

Design
Jan Le Witt and George Him

Jan Le Witt and George Him were something of a rarity, a graphic design duo, at a time when designers tended to work on their own or to be part of the growing trend for design teams. They had joined together because they felt that they had similar ideas and values and this communality seems to have been sufficiently strong to keep them working together for some twenty years in spite of very different, and not infrequently clashing personalities.

Jan Le Witt (born Lewitt), the younger of the pair, was born 3 April 1907, in Czestochowa in Central Poland, into a Jewish middle-class family.[1] Le Witt's early life was not easy: his father died when he was only thirteen; and the family property was confiscated by the Bolsheviks. This left him to fend for himself, and in his late teens he was to become something of a nomad, if not a drifter. He wandered around Europe and the Middle East labouring at whatever turned up. Through all his travels he sustained an early ambition to become a painter and, by chance, one of the jobs offered him was in a graphic design studio. From this experience he learnt that he had the talent to earn a living from design, although 'fine' art was ever present at the back of his mind.

From 1928 onwards Le Witt, without any formal art school training, worked as a freelance graphic designer. Amongst the early commissions he took was the design of a modern Hebrew typeface. He named this Chaim, (Hebrew for "life") and it came to be used in Israel. He must have been working on his painting at the same time, for in 1930 the Society of Fine Art of Warsaw gave him a solo exhibition; he was only twenty three. This seems to have given Le Witt sufficient courage to go to Paris the following year in order to further his painting ambitions. However, without a work permit

and with no income, he was obliged to return to Warsaw; yet the determination eventually to become a painter stayed with him. His previous contacts enabled him to pick up his design work from where he had left off before the Paris trip. It was at this point in his career that he was to meet up with George Him.

Born Jerzy Himmelfarb on 4 August 1900 in Lodz, Poland, also into a Jewish middle-class family, Him grew up in Warsaw.[2] A rather late developer in the field of graphic design. he had an extended period of academic study in Moscow and Bonn. At first he studied law at Moscow University, following his father's wishes, but when the law faculty was shut down during the Russian revolution, he turned to studying the comparative history of religions, completing a PhD at the University of Bonn in 1924. Him recalled later that by then a scholarly career was beginning to pall. As he had been drawing with enthusiasm since the age of three, he turned to studying graphic design and registered at the Akademie für Graphische Kunst und Buchgewerbe in Leipzig (1924-1928). Whilst Le Witt was wrestling with the diverging paths of designer and painter, Him was definitely set on a career as a designer from the time he left the Akademie. Later, talking about his career, Him was to use the words 'joy' and 'enthusiasm', qualities he considered inherent 'in the grand game of applying Art to Business'. Although a late starter, Him quickly caught up, gaining his first design commission in 1926, whilst still a student in Leipzig. He worked for a time in Germany, mainly providing illustrations for magazines, returning to Poland in 1933. Once back home in Warsaw, Him joined with other designers to form KAGR, the Circle of Advertising Graphic Artists. Le Witt and Him were said to have met in a café in around 1933 and, based on their subsequent friendship, decided to set up a design partnership. From the very beginning, their work was clearly signed, which was unusual in those days when much graphic design work would appear unsigned, or merely bear the name of the agency.[3] The pair began to find that the work they were producing together was quite different from, and better than, the work they had done individually up to that time; yet they have left no account of how this had come

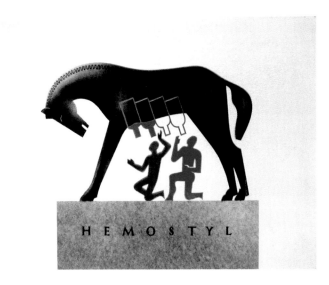

1934. Advertisement on the theme of Romulus and Remus for Hemostyl, a medicine derived from extract of horses' blood.

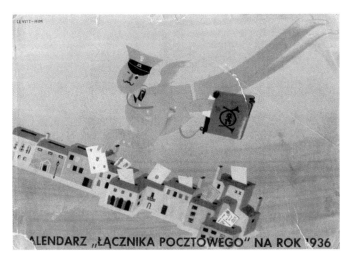

1936. 'Calendar of postal service for the year 1936'. Cover for small calendar for the Warsaw Post Office.

about, how they tackled any assignment, nor whether the partner who got the commission or had the original idea earned any kind of priority in its development.

Reading between the lines, the strength of the partnership lay in what psychologists term 'necessary conflict'. Gasser saw this mainly as a strength: 'because the continual friction which inevitably results from the union of two such strong and well-defined natures protects them from the primal dangers of all who occupy themselves with applied art: routine and mannerisms'.[4] Each acted as critic of the other, and the fact that the partnership lasted some twenty years says much for their shared intent, which seems to have counter-balanced their differences.

James de Holden Stone compares George Him to a mountain: 'huge, craggy, towering, immovable except by earthquake or taxi, the clouds near his summit clashing in lightning wit', whilst Jan Le Witt was seen as 'an alert jeep careering bravely round the passes, headlamps flashing in the intermittent sun, answering each thunderous crackle with hooting contradictions …I disagree… disagree… disagree'. He concludes: 'Mr. Him may soar, Mr. Lewitt may drive, but Lewitt-Him keeps an even keel, stays on the level, and never forgets the score i.e. what the client wants'.[5]

Some twenty years later, very near the time of the break-up of the Lewitt-Him partnership, a rather light-hearted interview in *Time Magazine* quotes Him as saying: 'When people ask why we collaborate, we ask "Why don't others do the same?"…Working together, we have this corrective thing all the time'. Says Le Witt: 'If you want to know who does what, we can't tell you anything. We think it's more interesting to leave people guessing.'[6] As, by then, the partnership was barely functioning, Le Witt was possibly reluctant to be questioned too closely.

Whatever the synergy between the two, it very quickly attracted commissions. During these early years in Warsaw they designed

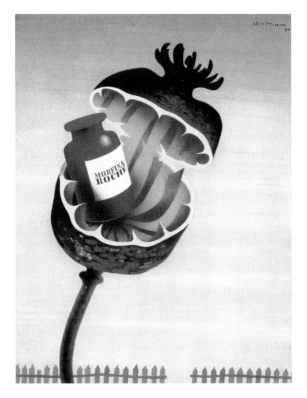

1937. Advertisement for Roche morphine, from the cover of a medical pamphlet.

posters, illustrations for information pamphlets for doctors, and press advertisements for various pharmaceutical companies. A major client was Roche, for whom they produced one of their most striking advertisements for a product aptly named 'morphia', manufactured from emptied poppy heads. It has all the characteristics of a modernist poster: few words (with striking typography), a simplicity of design with a minimum of detail, a strong use of space, and an element of surprise or shock – in the case of 'morphia', the enlarged and slightly menacing poppy head. Lewitt-Him designs increasingly used images that had a degree of

surrealism to them, obliging the viewer to take a second look. Again the *Time Magazine* article gives a clue as to what lay behind this in Le Witt's response to the journalist: 'If you can find something interesting in an object you can interest other people. People like the vague bit of a puzzle, and once they get into it, they feel they are taking part in the creation of it; just as they accept the challenge of a crossword.' Such a puzzle element was present in some of the Shell-Mex press advertisements in the '30s, for example when faces were hidden in landscapes for the reader to find.

It is perhaps difficult nowadays to appreciate the novelty of their use of strong colour, imaginative abstraction and symbolism on modernist graphics at this time; and, in turn, the impact of the arrival of the Lewitt-Him partnership in London.

During the early period together in Poland, they were involved with the poet and satiricist Julian Tuwim, a major figure in Polish cultural life at the time, writing, providing lyrics, founding a cabaret, and so on. Tuwim had joined with other poets to form a group known as *Skamander*, which produced a monthly magazine of the same name for which Le Witt and Him (as Levitt-Him) were to provide striking covers and illustrations. For one they mispelt the title as 'Skafander' [Polish for fish], an early example of their use of punning and word tricks. Again there is simplification, the prominence of one element (in this case a diver), and the use of shadowed lettering, so typical of modernist typography.

It was the partners' illustrations for Tuwim's charming children's book, *Lokomotywa* (1938), for which they are best remembered. When the English translation, *Locomotive*, was published in 1939, the illustrations were markedly different to English children's books of the time. The clarity and brilliant use of colour were nearest to Noel Carrington's lithographed Puffin Picture Books at the beginning of World War II. Noel Carrington was to become a great admirer of the Lewitt-Him partnership, and uses a number of examples of their work in his *Graphis* article on British Poster design during WWII.[7]

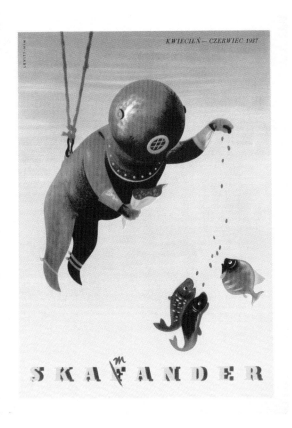

1937. Cover for *Skamander*, the monthly publication of the Skamander group of poets, formed after Poland gained its independence in 1918, which took its name from the river of ancient Troy. Le Witt and Him first met at the group's regular haunt, the Ziemianski café, in Warsaw.

By now their work was attracting professional attention and examples began to appear in design publications. Simultaneously their entries in such magazines as *Gebrauchsgraphik* and *Art et Metiers Graphiques* seem to have caught the eye of Philip James, at the Victoria and Albert Museum, and of Lund Humphries, the London publisher. Lund Humphries courted them to exhibit in the Lund Humphries Art Gallery, while the V&A asked for samples of work to include in

11

the collection. Both approaches suggested that there would be a good market for Lewitt-Him designs in London and triggered off the idea of relocation. Le Witt and Him's arrival in London should not be aligned with the onrush of artists and designers from the continent, fleeing Nazism; in fact it is thought that they were unaware of the imminent invasion of Poland and their vulnerability as Jews, rather being motivated by the idea of better creative openings.

It was the V&A who completed the necessary immigration forms with the result that the partnership was established in London by 1937. Lund Humphries, similarly to Curwen, combined a general printing 'works' in Bradford, with a London office at 12 Bedford Square. The Director there was Peter Gregory, a knowledgeable and enthusiastic art lover. He began to hold frequent, but irregular exhibitions in the Bedford Square ground floor offices. Ann Baer, a Chelsea art student at the time, recalls how the students would eagerly await each new show as an example of state-of-the-art graphics. The invitation to the Lund Humphries exhibition – entitled 'Commercial Art and Illustrations For Books by Lewitt and Him' – had an amusing representation of them as thin and thick paint brushes (representing their relative shapes!). The exhibition, along with the V&A sponsorship, must have considerably helped the pair gain a reputation and commissions in England. McKnight Kauffer, on the invitation to the exhibition, was quoted in their support 'I have known the work of Mr. Lewitt and Mr. Him through the pages of various periodicals. I was curious to see more of it, and when the opportunity arose, I found my interest and pleasure were not only sustained, but increased. They are comic, they are amusing, they are thoughtful, they are serious, and they are good advertising'.

One of their early clients was the Post Office, giving the pair their first commission in 1938 and, some 16 years later, one of their last as a partnership. The arrival of Stephen Tallents as publicity manager, straight from his highly successful but controversial work at the Empire Marketing Board, brought the rather conservative Post Office up on a par with the likes of London Transport and Shell-Mex when it came to design. Post Office publicity was used

to announce new products and generally to swagger, about the breadth of its services – postal and telegraph, banking and money transfer, pensions and licences, insurance – hardly an aspect of daily life was not within its orbit.

But Post Office publicity also had a 'nannying' role, one of seeing that the general public behaved in ways that eased the work of Post Office employees and improved their efficiency. The main targets for behaviour improvement were keeping to times of mailing, addressing mail correctly, and careful packaging (particularly important as both animals and people could still be sent by post at the time). It was these nannying campaigns with which the Lewitt-Him name became associated, particularly in wartime.

With so much manufacturing converting to munitions work (cutting out the need for marketing), and paper in very short supply and rationed, much commercial advertising was put on hold. The Shell-Mex publicity department, for example, was entirely shut down with the onset of war. Government publicity, however, was actually to expand during the war. The Germans were well ahead, even before the start of the war, with their Ministry of Propaganda, under Goebbels; whilst the British were still dithering as to whether to have a Ministry of Information or not. Even when one was set up, Ministers and Directors-General were to come and go with rapidity until in 1941 it became relatively stable and began operating effectively with Brendon Bracken as Minister and Cyril Radcliffe as Director-General.

Commentators, such as Eric Newton, art critic for the *Sunday Times*, argued the Government's need for posters for putting the essential messages across, appreciating that the eye was quicker at responding to shapes than to words. Le Witt and Him were to find themselves in an elite group of designers working on wartime posters, being spoken of alongside the likes of Abram Games and Tom Eckersley. Rickards felt that the war brought out the best in graphic designers – that a designer with a cause was better than his commercial alter ego. He rated the wartime work of the pair as 'significant'.

The Lewitt-Him partnership produced some iconic images for a number of government departments. The Post Office – faced with massive relocation of people, bombing of homes and workplaces and enlistment into the services – had a particularly strong need. The pair produced more than a dozen posters urging people to post at optimum times, not to use overstretched services that were needed for the war effort, and urging people to keep up their communications with their friends and relatives in the fighting forces to boost their morale.

The partnership also did work for the Ministry of Information on the 'careless talk costs lives' theme, for the Ministry of War Transport urging people to walk rather than use up essential petrol supplies; and for the Ministry of Food encouraging home growing and optimal use of rationed goods. Their designs 'Use Shanks' Pony' and 'Vegetabull' were memorable amongst the plethora of government posters. The 'Shanks' Pony' poster illustrates how the pair could take a rather commonplace brief – 'a pony followed on foot by John Citizen and his family', and, with their quirky humour, produce a poster with impact. They also produced posters for the Royal Society for the Prevention of Accidents (RoSPA). During the war people were drafted into munition works who had never experienced factories before and were vulnerable, having only minimal safety training. The Lewitt-Him posters for RoSPA ran along the lines of 'The smallest wound may cause the biggest trouble' and 'Pull your load if you can't see over it'.

Although Le Witt and Him were both contemplating British naturalisation they were still very close to their Polish roots and they undertook a variety of assignments for the Polish government in exile and other Polish organisations during the war. The partnership produced *Polish Soldiers in Norway*, recording the Battle of Narvik, as well as providing illustrations for the Polish Journal *Underground Poland Speaks* and for *Informator*, an information booklet for Poles in England. They also wrote and illustrated – with photographs and some charming little vignettes – *Polish Panorama*, a journey through their motherland (1941). It presented a picture of

1933-1937. Advertisement for pain relief medication.

Poland at peace with the hope that this state could soon be restored, ending on a nostalgic note: 'But to-morrow is also a day, and no tyranny can eradicate from a man's heart the love of his native soil'. It was to be some thirty years before Le Witt was to make a return visit; some forty-four for Him.

They were also to do work for the Dutch authorities located in London, including the dramatic poster 'The black market is anti-

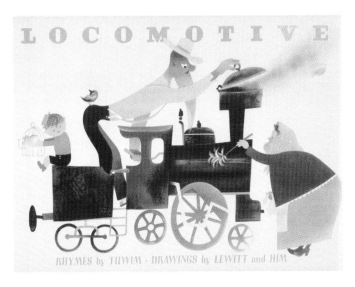

1938. Book cover for *Locomotive*, book of three poems by Julian Tuwim: 'Locomotive', 'The Turnip', and 'The Birds' Broadcast'. Originally published as one book in Polish by J. Przeworski, Warsaw, and subsequently in English and French. The Lewitt-Him partnership was instrumental in bringing the use of shading in printed blocks into England.

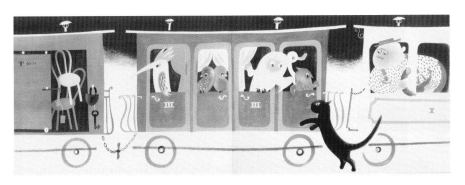

1938. Endpapers to *Locomotive*. Here the locomotive is filled with characters from 'The Turnip' and 'The Birds' Broadcast'.

16

L O C O M O T I V E

1938. *Locomotive*. Title page to the poem, 'The Locomotive', one of Poland's best-loved children's poems.

1938. *Locomotive*. Book illustration for the poem 'The Turnip' - "still the turnip stuck in the ground".

1938. *Locomotive*. Book illustration from 'The Birds' Broadcast' - "the meeting".

1938. *Locomotive*. Book illustration for the poem 'The Birds' Broadcast' - "the birchwood grove".

18

Dutch', which came out on the eve of invasion. Something new for the partnership was the mural for a factory in Langley, Bucks. One hundred and twenty feet in length, it was based on old Russian fables linked to English nursery rhymes. They aimed to relate the morals of the fables to aspects of wartime production, though the complexity of this almost certainly would have eluded the majority of the factory hands eating there. The post-war period saw the Lewitt-Him partnership expanding its general commercial work. Airlines seem to have become a speciality, with designs for Imperial Airways, Pan-American Airways, and, most frequently, American Overseas Airlines, a commission gained through the Council of Industrial Design (CoID). By now the Lewitt-Him style was immediately recognisable. Tomrley described it as 'the grim joke meeting the grim situation, the puns, the teasing, the inconsequent, the fantastic and the grotesque'.[8] She quotes Le Witt and Him as claiming that it was Carrol and Lear who taught them to understand and to love the British mind.

And then came the Festival of Britain. The pair had already been involved in exhibition work for their adopted country before the Festival. The newly elected government in 1945 began immediately heralding a new Britain, and, within a year or two, the Welfare State had been set up. Surprisingly, art and design were recognised in the welter of acts for children, education, health, and the likes. The Arts Council emerged from the wartime maverick Council for the Encouragement of Music and the Arts (CEMA); and along with this came the Council of Industrial Design (the Design Council to be).

CoID was quickly to show its colours when Sir Stafford Cripps, President of the Board of Trade in Attlee's government, conceived the idea of filling the empty rooms of the Victoria and Albert Museum with a display showing off Britain's transformation from munitions to peacetime manufacturing: the 'Britain Can Make It' exhibition (1946). It was a rushed job, put on in just over a year, with Cripps demanding that it should give the public a lift even if goods were still scarce. (Although the underlying purpose of the exhibition was to boost British exports in view of the considerable

expansion of America's export trade during the war.) James Gardner was appointed as coordinating designer and, taking Cripps at his word, he put display to the fore, sometimes so much so that visitors had to search for the goods being shown. The Press generally found the displays more impressive than the goods; Raymond Mortimer wrote that the settings were so flamboyant they actually undermined the impact of the goods.[9] Two of the display stands – a larger-than-life pageboy to show off luggage, and a tree hung with umbrellas – were Lewitt-Him designs. In Gardner's tongue-in-cheek account of designing the exhibition he refers to this tree... 'I make a detour to evade two argumentative Czechoslovakian geniuses, Lewitt and Him, who are arranging umbrellas on a stylised cut out tree...'[10] Although Gardner got the nationality wrong, he got the 'genius' right and he obviously was aware of the 'necessary conflict' at the heart of their creativity.

The Festival of Britain had rather different aims to 'Britain Can Make It', which was more in the way of a trade fair. The Festival has variously been described as the 'British contribution to world civilisation' and 'a tonic for the nation'. The two main London sites were the South Bank and Battersea. The South Bank had rather an educational tinge, and Gerald Barry, the Festival Director, felt the need for some fun. Remembering the old Vauxhall Pleasure Gardens he set out to make the Battersea site 'elegant fun'. Again, James Gardner was to be the co-ordinating designer.

Whereas the Lewitt-Him team went relatively unnoticed among dozens of designers for 'Britain Can Make It', their contribution at Battersea became a major draw on the site. Advertising was allowed at Battersea, and Martin Pick, then advertising manager for Guinness, took full advantage of this. He came up with the idea of a Guinness Clock, to feature some of the Guinness animals created by John Gilroy for Guinness's press and poster advertising, so familiar with the public. Guinness had also previously made use of *Alice in Wonderland* characters and it was decided to include the Mad Hatter along with the star Guinness animal – the toucan.

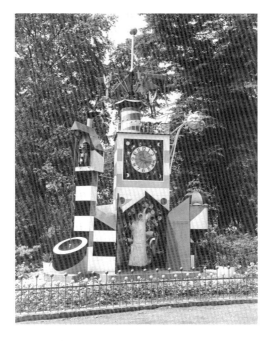

1951. 'The Guinness Clock' from the Festival of Britain. Made by clockmakers Baume & Co Ltd of Hatton Garden.

The Lewitt-Him design proved a winner. The clock stood some 25ft high and was said to have the most complex mechanisms of any clock built for over three hundred years. Every quarter of an hour there was a routine; Brian Sibley gives a vivid description: "…the eccentric little building burst into life: the sun spun round; the keeper [said to be in the likeness of Gilroy] rose from under an umbrella ringing a bell; the ostrich emerged from a chimney; marionettes revolved on a whirligig; the Mad Hatter came out of his house and fished up a diminishing string of fishes from a pond, and finally the doors opened to reveal a pair of toucans pecking at a Guinness Time Tree hung about with watches'.[11] All of this was accompanied by nursery rhyme tunes.[12]

John Barmas records seeing Le Witt (grey-haired) and Him (twenty-one stone) admiring their work describing them as 'dreamers who had fought time, prejudice, drabness with their own gaiety'.[13] Barmas describes how, although neither of the pair

were at all mechanically minded, and were only given a few months for the design, they devised a clock that not only attracted attention when still, but they had resolved how to make the emerging figures fold or telescope, be suspended or anchored, and emerge with éclat every quarter-of-an-hour. They had made three-dimensional paper models from which, with considerable birth pains, the Guinness Clock was born.

The popularity of the clock was such that smaller versions were made to travel the country for the next seven years or so, setting down at seaside resorts and in shops, such as Lewis's store in Manchester. Countless individual memories of the Festival are of childhood visits when parents were nagged, every quarter of an hour, to return to watch the Lewitt-Him ingenuity and sheer fun. It was in this post-war period that the partners began working for Schweppes. For the Festival they designed a bottle carrier for Schweppes squash, and then came Schweppshire.

There had been previous advertising campaigns that had achieved cult status, such as Betjeman and Bawden's town series for Shell, but Schweppshire could claim the distinction of being one of the longest running. Although this campaign started within the Lewitt-Him partnership, it was Him who made it his own, working along with Stephen Potter's texts for some dozen years.

Schweppes started to invest heavily in advertising and Him was to take full advantage of this, providing posters, labels and displays, as well as the Schweppshire designs. Stephen Potter, by the early '50s, was a highly successful writer and BBC producer, and had gained an international reputation as a satirist with his *Lifemanship/Oneupmanship* books. Him's quirky visual humour married in well with Potter's style and together they invented and peopled the imaginary county of Schweppshire, punning their way along with sideways swipes at British institutions and customs. David Gentleman suggests that it might be because Him was Polish that he could conjure up such an assemblage of English quirks so sharply. Him and Potter's not too

unkind merrymaking very quickly increased Schweppes' profits. The popularity of the campaign now seems remarkable in that both words and pictures were crammed with cultural and intellectual references of a cleverness beyond the average audience.

After the initial success of *Locomotive*, the Lewitt-Him partnership went on to illustrate four more children's books: *Blue Peter* (1943) and *Five Silly Cats* (1944), both written by Le Witt's wife Alina; *The Football's Revolt* (1939), which they wrote themselves; and, probably the best known, *The Little Red Engine Gets A Name* (1942), which was the very first of Diana Ross's *Little Red Engine* books.

Their children's book illustrations are immediately recognisable as having Eastern European roots. Though they have a kind of whimsy that also could be applied to English illustrators, their images are firmly rooted in Polish culture – a cross between peasant popular art and modernism – forceful chunky shapes and flat blocks of colour, bearded and moustached faces even when, as with *Little Red Engine*, the setting was an English branch line with the English monarch's luggage, and indeed the King himself being carried.

After the partnership split, book illustration became a major part of Him's work. He went on to illustrate some twenty or so children's books, most notably the *King Wilbur* series by Jim Rogerson, broadcast on Thames Television (1974-1976), and the *Giant Alexander* series by Frank Herrmann, broadcast on the BBC's *Jackanory* and *Play School* (1964-1975). Him also illustrated literature, including Max Beerbohm's *Zuleika Dobson* and Shaw's *Two Plays for Puritans*. In 1977 Him was awarded a prize by the V&A Frances Williams Book Illustration Award Scheme.

As well as enjoying commercial success, Lewitt-Him design work was exhibited internationally: in Stockholm in 1948, and 'Art to a Purpose' at the Jewish National Museum, Bezalel, Israel in 1950. In 1953 they were honoured to be invited to exhibit for Associated American Artists "AAA" in New York; this was to prove their farewell show.

Ambivalent about becoming a designer from the start, Le Witt continued to paint and exhibit throughout the partnership. It is significant that his first friends and supporters on his arrival in England were Henry Moore and the art critic, Herbert Read (who was later to contribute to the only monograph on Le Witt); whereas Him was to line up with the design fraternity, being particularly close to Hans Schleger (Zero).

As early as 1942 Le Witt was included in an exhibition of Allied Artists in Edinburgh. From 1945 he was devoting an increasing amount of time to painting, cramming in his design work during the day and painting in the evening. He began showing in London at Zwemmer's, the Leicester and Hanover Galleries, as well as doing designs for Sadlers Wells. Eventually the scales tipped overwhelmingly in favour of 'fine' art and, on 1 January 1955, the partnership was dissolved.

Le Witt devoted himself thereon to his art. His paintings are said to have a lyrical, poetic quality, earlier on influenced by Klee and rather fanciful, but, after a period of retreat, his work became increasingly abstract, with experiments using thick colour and varied surface textures. Although he was given a retrospective in his native land, at the Museum of Modern Art in Warsaw (1967), he was never to feel that he had had the appreciation that he deserved. He must have wondered, from time to time, what he might have achieved had he committed himself purely to 'fine' art much earlier. Read's contribution to the monograph on Le Witt has no reference at all in the text to Le Witt's twenty successful years of design, as though he had just blanked them from his mind or felt that mention of them would in some way have reduced his artistic reputation.

George Him, on the other hand, was a committed designer from start to finish. In notes for 'Fat Person Singular', an exhibition of his work given by the London College of Printing by invitation from Tom Eckersley (1976), he wrote: 'Actually, I managed to do for money, what I would have done in exactly the same way had I been working for my own satisfaction'.[14] On his own, he continued with

book illustration and general commercial work (designing posters, labels, adverts, book covers and trademarks for a mêlée of companies from Horizon Holidays to Chivers Jam, from Formica to Penguin Books) and, of course, Schweppshire. Him's commissions also included 3-dimensional design, such as toys for the firm Britains, exhibition stands for Philips and the Australian Trade Commission, and window displays, as for example, a splendidly festive Christmas display for the Design Centre.

Just as Le Witt and Him's Polish roots were still with them in some of their war work, so Him's Jewish roots were to dictate a good deal of his work after the break-up. Him was involved in two major exhibitions in London: he was one of two honorary designers for the 'Warsaw Ghetto' exhibition held at the Herbert Samuel Hall (1961), and was both originator and designer for the 'Observer Masada' exhibition held at Festival Hall (1966).

For the 'Warsaw Ghetto' exhibition – photographs, documents and relics from the years 1939-1943 – Him provided a chilling poster, which also served as the cover to the exhibition catalogue. The starkness and sheer horror of his image harked back to the cold mechanical geometry of Vorticism. The 'Masada' exhibition was entirely Him's brain child: he conceived the layout, the display units and the simple logo.

A major commission for Him was his appointment as chief consultant designer for the airline El Al's re-branding exercise. His comprehensive responsibility for El Al's new corporate image spanned everything from stationery and luggage to aircraft identification logos; and his brief also encompassed the worldwide revamping of the El Al shops and offices, for which Him's extensive knowledge of languages (he is said to have spoken at least seven) proved invaluable. Him also designed for many Jewish charities and appeals, and provided covers and illustrations for books and pamphlets on Jewish matters, such as *Jewish Perspectives: 25 Years of Jewish Writing*, *Jerusalem Revealed* (recording the work of the Israel Exploration

Society) and the journal *New Middle East*. Much of Him's work for Israeli charities was through Teddy Kolleck, the Mayor of Jerusalem, whom he had known when young. Through Kolleck, Him acted as designer for the Israeli Pavilion at Expo 58 in Brussels, and as chief designer for the Israeli Pavilion at Expo 67 in Montreal.

George Him died in 1982, Le Witt in 1991. Together, they brought to British design an energy, inventiveness and humour, rooted in their own culture, yet with a simple accessibility and universal appeal. Him, working on some twenty-eight years without Le Witt, realised that graphic design was changing beyond his willingness to adapt. Looking back on his career he wrote: 'I am roughly as old as graphic design in the modern sense and have watched its development, for better or worse, into a proper profession.' (Him taught design at Leicester Polytechnic from 1969 to 1977).

In a talk to the Alliance Graphique Internationale conference in St. Germain-en-Laye in 1960, George Him defined the creative process as he saw it: "a fragile thing, born out of soul-searching and grappling in the dark"; and yet he found no difficulty in applying this struggle to himself and his fellow graphic designers, whom he saw as "not great artists graciously descending from their ivory towers to paint a pretty picture for an enterprising manufacturer, but practitioners, realising that design must be an art, serving a clear-cut purpose and judged, not merely by aesthetic standards, but also by the degree in which it fulfils its given task."[15]

Jan Le Witt and George Him, in their work together as Lewitt-Him, not only set such professional standards – once described as providing an unattainable model of perfection – not only met each brief efficiently within time and budget, but gave added value to each task by giving pleasure to the public with their wit and sheer fun – both to children and to the child-in-the-adult.

26

Lewitt-Him: Commercial Work 1937-1944

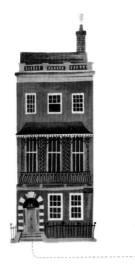

1937. Invitation to 'Lewitt and Him Exhibition of Commercial Art and of Illustrations for Books', which was held at Lund Humphries' London Gallery.

LUND HUMPHRIES

invite you to an Exhibition

of Commercial Art and of

Illustrations for Books by

LEWITT and HIM

to be held at 12, Bedford

Square, London, W.C.1, from

November 24 to December 15

● 12, Bedford Square, W.C.1

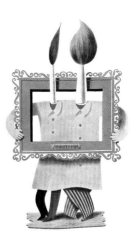

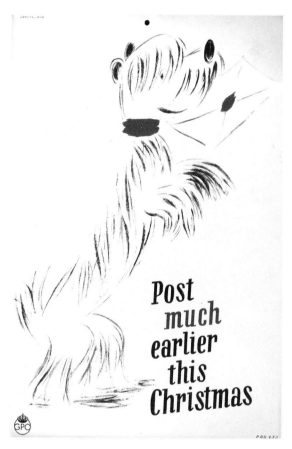

1940. 'Post much earlier this Christmas'. Poster for Post Office used during the first months of the Blitz.

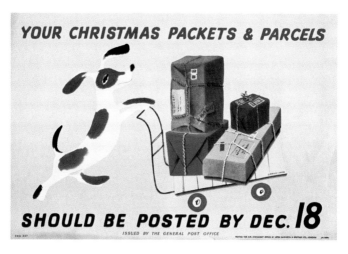

1941. 'Your Christmas packets and parcels'. Poster for Post Office.

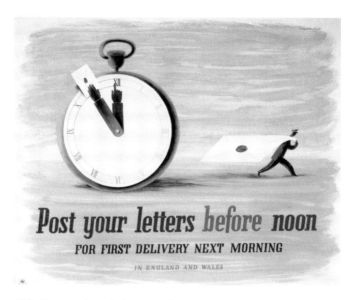

1941. 'Post your letters before noon'. Poster for Post Office used during the Blitz, encouraging the public to ease the burden on the Post Office, which was suffering from labour shortages and petrol rationing.

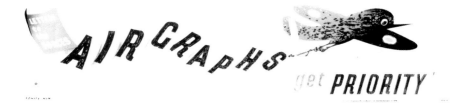

1943. 'Airgraphs get priority'. Poster for Post Office, advertising Airgraph communication between troops and family. The system, whereby messages were written on a special form, microfilmed at a processing station and reprinted at their destination, carried 350 million messages between 1941 and 1945, saving 4500 tons of airfreight.

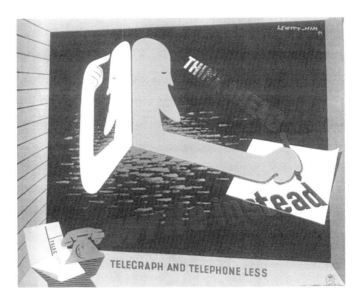

1944. 'Think ahead, write instead'. Poster for Post Office, part of a campaign during WWII to urge the public to use the telephone less. The network of the day had limited capacity, so it was important to give priority to official calls and telegrams.

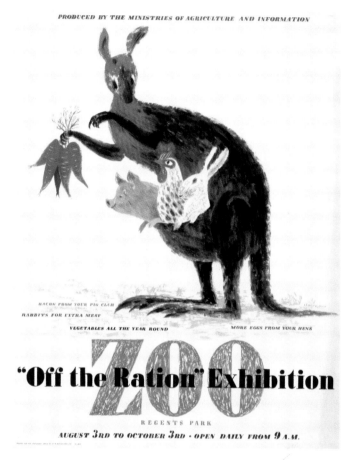

PRODUCED BY THE MINISTRIES OF AGRICULTURE AND INFORMATION

BACON FROM YOUR PIG CLUB
RABBITS FOR EXTRA MEAT
VEGETABLES ALL THE YEAR ROUND MORE EGGS FROM YOUR HENS

"Off the Ration" Exhibition

REGENTS PARK

AUGUST 3RD TO OCTOBER 3RD · OPEN DAILY FROM 9 A.M.

1942. 'Off the Ration'. Poster for Exhibition held at Regents Park Zoo at a time of food rationing, with information about how to provide additional food for the family through schemes such as "pig clubs", "keep a rabbit" and "how to get more eggs from your hens".

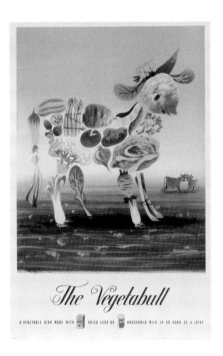

1943. 'The Vegetabull'. Poster for the Ministry of Food encouraging the substitution of vegetable dishes for meat. The charm and humour of such Lewitt-Him designs struck a chord with the English public.

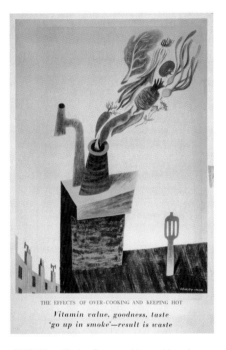

1943. 'The effects of overcooking and keeping hot'. Poster for the Ministry of Food. George Him used to complain to fellow designer and friend Hans Schleger that the English always overcooked their vegetables.

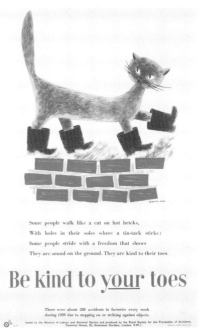

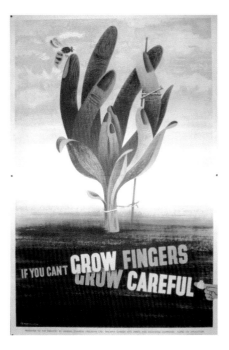

1942. 'Be kind to your toes'. Poster for Ministry of Labour for prevention of foot accidents. The government was concerned about loss of manpower through injury at work.

1943. 'If you can't grow fingers'. Poster to promote accident awareness in war factories. The use of surrealism and ambiguity is typical of government propaganda of the time, which sought to encourage and remind, in contrast to the didactic approach of WWI government propaganda.

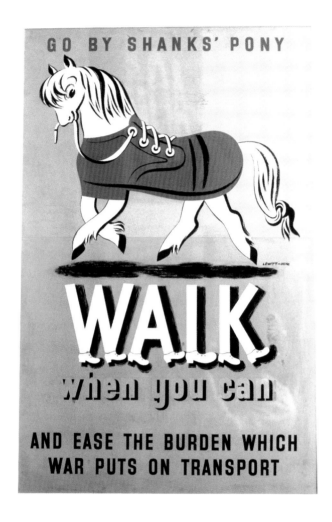

1942. 'Shanks' Pony'. Poster for Ministry of War Transport. Three variations exist; the artists chose to put this booted "WALK" version into *Graphis* (1946), and *Gebrauchsgrafik* (1953). George Him's father, Jacob Himmelfarb, was a major shoe manufacturer in Poland.

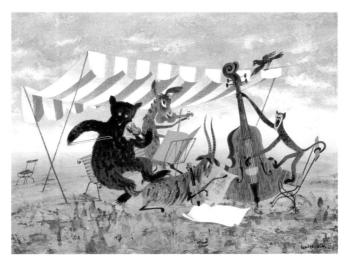

1942. Factory canteen mural for Langley Alloys Ltd, Langley, Bucks., a metal pro-
duction company that produced engine parts for the Spitfire aircraft during WWII.

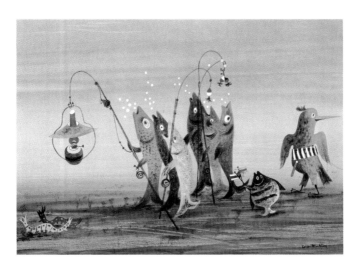

1942. Factory canteen mural for Langley Alloys Ltd. Later re-issued as a series
of prints for Carlton House.

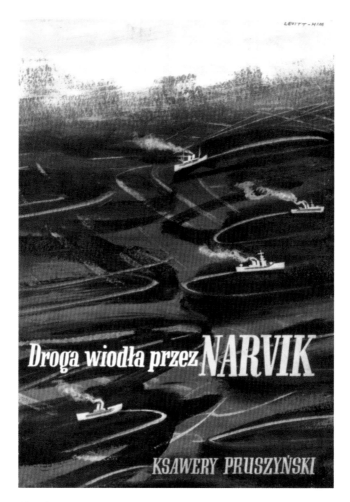

1944. Bookcover. *The journey led through Narvik.* Tribute to the bravery of Polish troops who fought for Narvik, an ice-free seaport on the west coast of Norway.

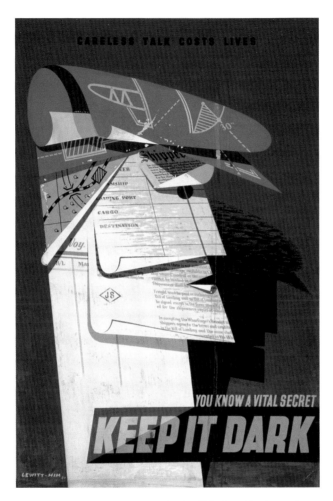

1944. 'Keep it dark'. Poster for the 'Careless Talk Costs Lives' campaign, produced by the Ministry of Information.

Lewitt-Him: Book Illustration

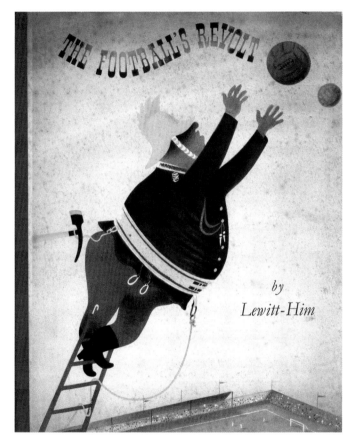

1939. Bookcover for *The Football's Revolt*, pictures and words by Lewitt-Him, published by *Country Life*, London. Frank Herrmann, who later wrote the *Giant Alexander* books, writes that this was one of his favourite books as a child.

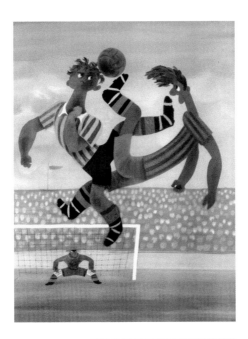

1939. Book
illustrations from *The
Football's Revolt*

"the men kicked him
harder and harder".

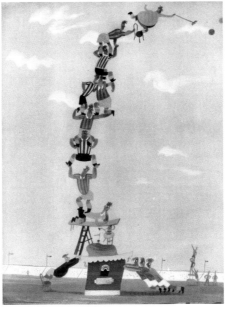

"the pyramid".

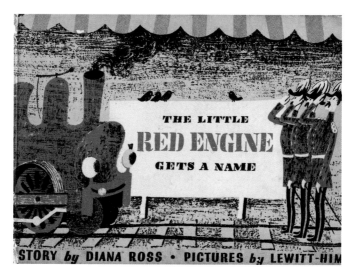

1942. Bookcover for *The Little Red Engine Gets A Name* by Diana Ross, published by Faber. Diana Ross thought up the story for her nephew Jonnie. Whenever he came to stay he went straight to the drawer where she kept a little old toy tin engine that was red.

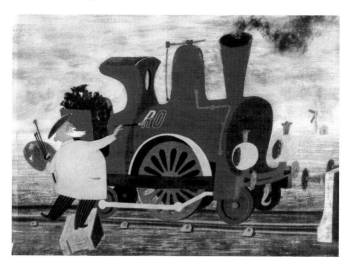

1942. 'Royal Red'. Book illustration from *The Little Red Engine Gets A Name*. During WWII all engines were painted black, so it was a matter of some amusement at the time that the Little Red Engine was the only engine to have a colour.

Once upon a time there was a Little Red Engine. It lived in a shed with a Big Black Engine and a Big Green Engine at the junction of Taddlecombe, where the great main line to the North, and the great main line to the South met the little branch line on which the Little Red Engine was running.

1942. 'The little branch line'. Book illustration from *The Little Red Engine Gets A Name*. A branch line also ran past Diana Ross's house.

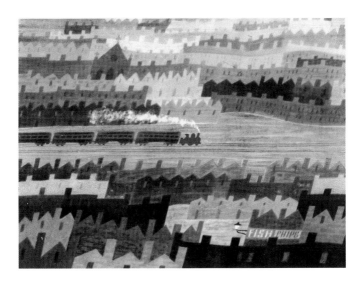

1942. 'The backs of houses'. Book illustration from *The Little Red Engine Gets A Name*.

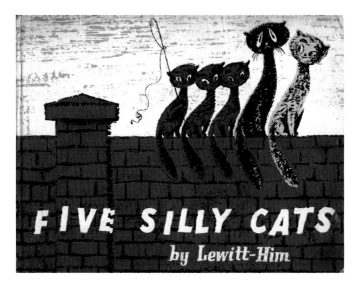

1944. Bookcover for *Five Silly Cats*, words by Alina Lewitt (Jan Le Witt's wife) and illustrations by Lewitt-Him, published by Minerva.

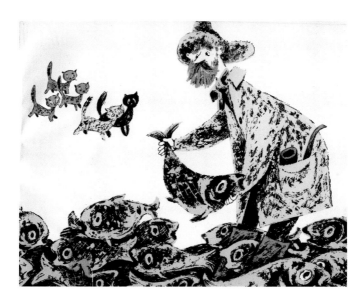

1944. Book illustration from *Five Silly Cats* – "an old fisherman".

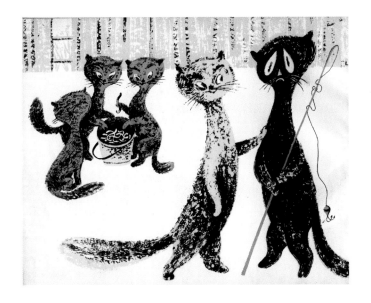

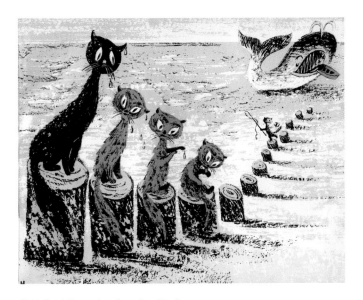

1944. Book illustrations from *Five Silly Cats*.

Lewitt-Him: Commercial Work 1945-1954

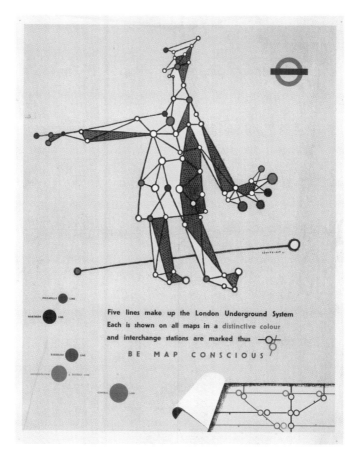

1945. 'Be map conscious'. Poster for London Transport, re-acquainting the public with the different colour codes for each of the five lines on the London Underground. Bottom-right, the Beck map of 1933.

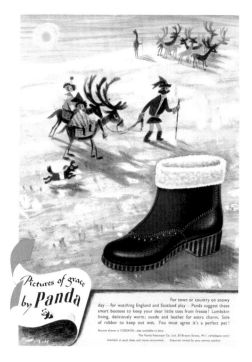

c1946. Advertisement for Panda shoes.

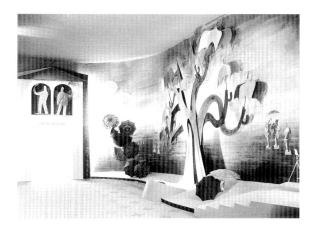

1946. Exhibition display. 'The Umbrella Tree' for the 'Britain Can Make It' Exhibition.

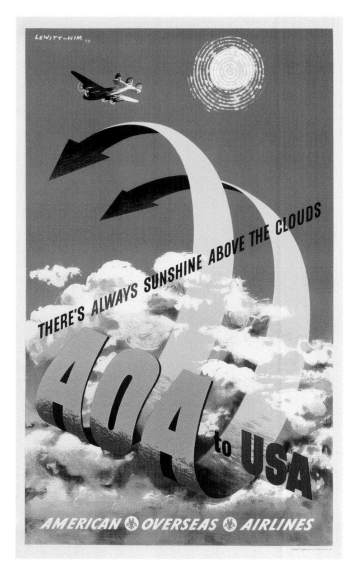

1947. 'There's Always Sunshine'. Poster for American Overseas Airlines. The aeroplane emerging from its victory roll is a Lockheed Constellation.

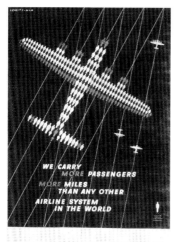

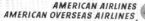

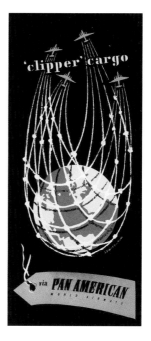

1949. 'We Carry More Passengers'. Poster for American Overseas Airlines. AOA was formed in 1945 when American Export Airlines merged with the transatlantic division of American Airlines. The Aeroplane in the poster is a Lockheed Constellation, identifiable by its long nose.

1952. Leaflet for Pan American World Airways, which acquired AOA in 1950.

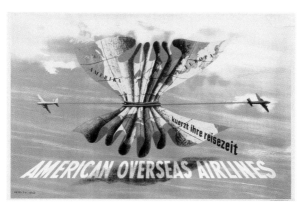

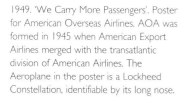

1948. 'Shrinking Travel Time'. Poster for American Overseas Airlines. This poster represented the Lewitt-Him partnership in Henri Henrion's book, *AGI Annals*. The planes featured are Douglas DC4s.

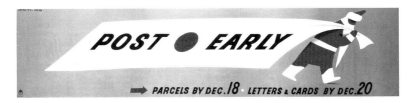

1948. 'Post Early'. Poster for Post Office.

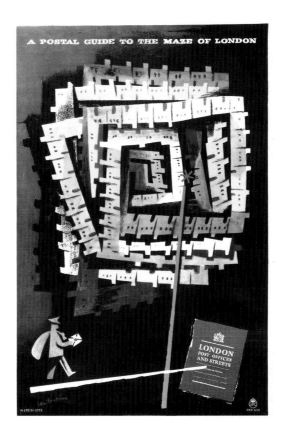

1951. 'A Postal Guide to the Maze of London'. Poster advertising the Post Office publication *London Post Offices and Streets*.

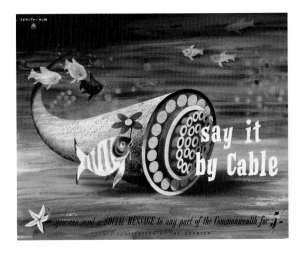

1951. 'Say it by Cable'. Poster for the Post Office. During WWII
the submarine telegraph cables in the Mediterranean were cut.
Greetings telegrams were re-introduced on 20 November 1950; a
message of thirteen words could be sent anywhere in the
Commonwealth for five shillings.

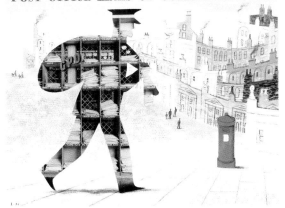

1950. 'Lines of communication'. Poster for the Post Office. Part of
the series stressing the national importance of the day-to-day
services offered by the Post Office at that time. This one
advertises postal services, the other two advertise telegraph
transmissions and radio telephone services.

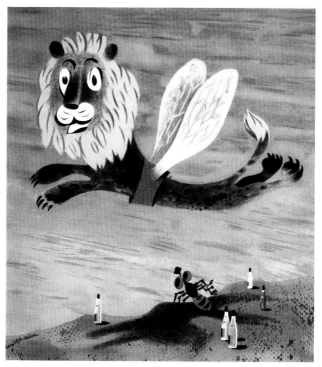

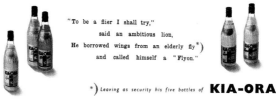

"To be a flier I shall try,"
said an ambitious lion,
He borrowed wings from an elderly fly [*]
and called himself a "Flyon."

[*] *Leaving as security his five bottles of* **KIA-ORA**

KIA-ORA THE MOST DELICIOUS OF ALL FRUIT DRINKS · ORANGE · LEMON · GRAPE FRUIT · LIME · LEMON BARLEY

1949. 'An Ambitious Lion'. Advertisement for Kia-ora (which means "good-morning" in Maori). Originally an Australian product, it became a subsidiary of Schweppes.

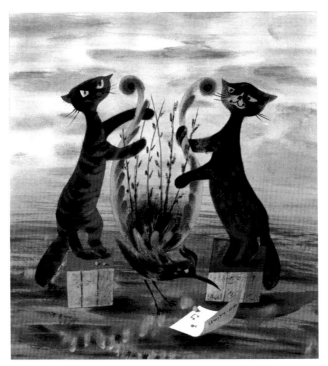

 Ginger Cat and Black Cat
played a tune in E-flat.
They found Lyre-Bird's tail
a most useful detail *)

*) *The cats' fee per concert was five bottles of* **KIA-ORA**

KIA-ORA THE MOST DELICIOUS OF ALL FRUIT DRINKS · ORANGE · LEMON · GRAPE FRUIT · LIME · LEMON BARLEY

1949. 'Ginger Cat and Black Cat'. Advertisement for Kia-ora. This started off life as a dummy book of illustrated rhymes by Lewitt-Him called *Funnymals*.

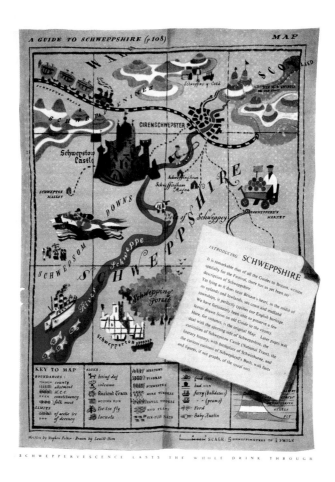

1951. 'A Guide to Schweppshire'. Advertisement for Schweppes. Text by Stephen Potter, who co-created the project with Schweppes's Managing Director, Sir Frederick Hooper, with the idea that it should "be like the rest of Britain only more so".

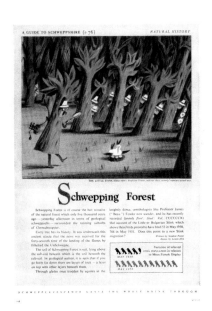

1951. 'Schwepping Forest'. Advertisement for Schweppes. Text by Stephen Potter. From the series 'A Guide to Schweppshire'.

1953. 'Re-inhibitating Centre'. Advertisement for Schweppes. Text by Stephen Potter. From the series 'Schweppshire Shows the Way'.

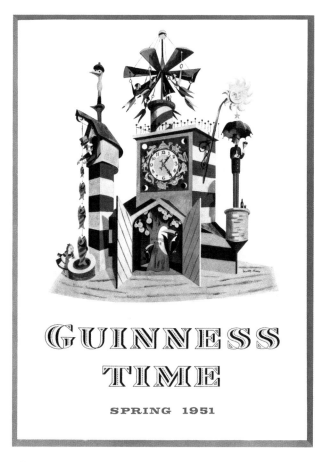

1951. 'The Guinness Clock' from the Festival of Britain. Made by clockmakers Baume & Co Ltd of Hatton Garden.

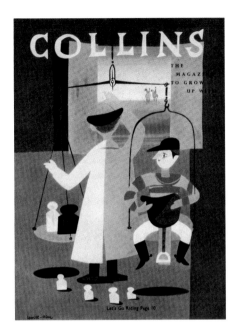

1953. 'Let's Go Riding'. Magazine cover for *Collins*, a publication for older children.

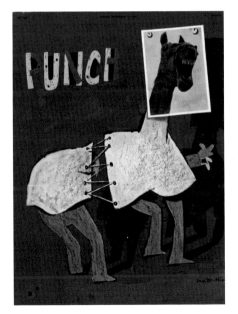

1954. Magazine cover on the pantomime theme for *Punch* magazine.

George Him: Commercial Work

c.1957. George Him.
'Oranges & Lemons'.
Advertisement for
Technicolour, part of a
series. George Him
chose this piece to
represent his work at
the 25th Anniversary
Congress of the AGI in
Venice, 1977.

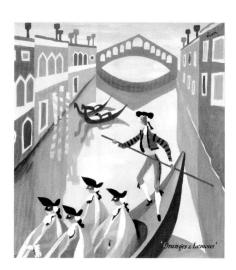

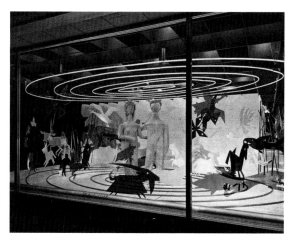

1957. George Him. Window display for the official opening of the
De Bijenkorf department store in Rotterdam.

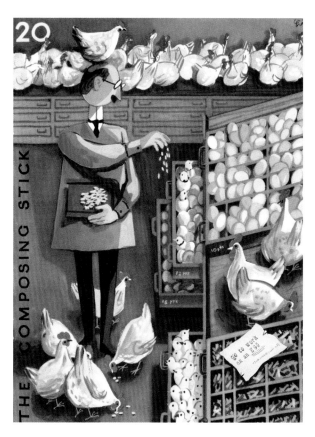

1958. George Him. 'Go to work on an egg'. Cover for *The Composing Stick*, the in-house magazine for the Upton Group of printing companies.

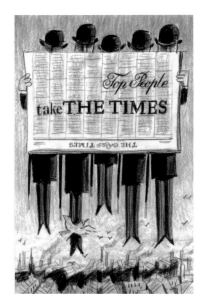

c.1960. George Him. 'Top People Take *The Times*'. Wax crayon sketch for poster. One of several suggested sketches for this campaign from which two posters by George Him were selected.

1961. George Him. Display for Penguin Books with Him bookcover. "To be effective a point-of-sale unit must give affirmative answers to five leading questions – Will it travel? Will it print? Will it stand? Will it group? And will the dealer like it?" Him, *Art & Industry*, 1957.

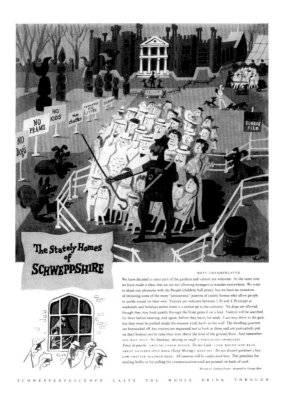

1957. George Him. 'Wett Chamberlayne'. Advertisement for Schweppes. Text by Stephen Potter. From the series 'The Stately Homes of Schweppshire'.

TRADITION IN SCHWEPPSHIRE

6. LOVE OF ANIMALS

One of the most constant characteristics of Schweppshire has been love of animals and it is perhaps fitting to close this present series with some attempt to clear up a few misunderstandings here. Being pro animals, we have lots of rules and societies and laws to make sure that everybody is fond of them all the time, except of course for killing them.

To certain primitive peoples, who do not understand the Schweppsian way of life, our animal rules are not perfectly clear, except for shooting them. Our Friends of Feathers Society, for instance, wants to keep down Philpott's Harrier because Philpott's Harrier eats the eggs of the Little Stink. Actually Philpott's Harrier is being kept down by NASTIFLY, the insecticide used on turnips, the tops of which Philpott eats for his vitamin C: but we are against this because it is

against the balance of nature, which of course is also why we kill them, because if we did not kill the animals we kill they would not only be killed anyhow, they would not be born. If they could be asked whether they would rather be born with a sporting chance or not born at all, we never have a moment's doubt what any British animal would choose.

Having cleared that point it remains to explain game laws, which recently reached such a point of complexity that we found it simpler to limit times of killing anything at all to during the six weeks following the first Friday the 13th in the year, and tea-time to teatime on alternative Thursdays and Fridays. But of course anything larger than a germ but smaller than a pigeon must not only never be killed, it must be treated tremendously kindly.

Written by Stephen Potter; designed by George Him

SCHWEPPERVESCENCE LASTS THE WHOLE DRINK THROUGH

Schweppes Prestige Ad. No. 6
Appearing Sept. 1963 in all publications on the Prestige Schedule
C.R.P. 7221-1 11.6.4

1963. George Him. 'Love of Animals'. Advertisement for Schweppes. Text by Stephen Potter. From the series 'Tradition in Schweppshire'.

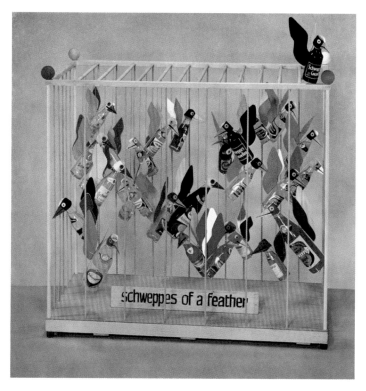

c.1959. George Him. 'Schweppes of a Feather' display. "The bottles themselves are very much part of the design, and the colour of the contents, as well as the colour of the label, etc, play a part in deciding the design of the overall display." Him, *Art & Industry*, 1959.

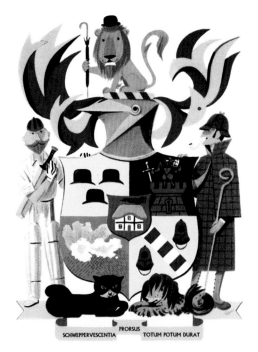

SCHWEPPSHIRE, COUNTY OF

Arms–Quarterly: 1. or three bowlers sable, *for City*; 2. sable the battlements of a tower gules, thereon a ghoul ancestral also gules holding in the dexter hand a sword point downwards and supporting with the sinister arm a head truncated argent, *for Schwepstow*; 3. azure a cirro-cumulus therefrom issuing rain proper, *for Fogschwepster*; 4. or a bend gobony azure and argent between two helmets Metropolitan azure, *for Schweppesminster*. **Inescutcheon**–vert Ye Olde Cottage proper, smoke passant sable, *for Isle of Schweppey*. **Crest**–Lion sejant guardant proper, armed umbrella sable, crowned bowler proper. **Supporters**–dexter: a batsman habited argent, capped vert, bearded gules, holding cricket bat proper; sinister: a Sherlock proper holding in mouth a meerschaum or.

c.1960. George Him. 'Schweppshire Coat of Arms'.
Advertisement for Schweppes. Text by Stephen Potter.

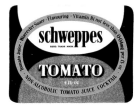
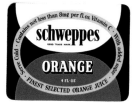
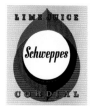

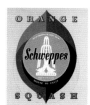
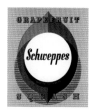
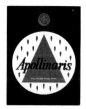
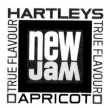
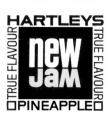
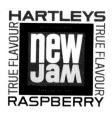

c.1960. George Him. Bottle labels for Schweppes, Apollinaris, Hartleys and Chivers. In 1960 Schweppes took over Hartleys and Chivers. Sir Frederick Hooper attributed the success of Hartleys New Jam directly to the impact of George Him's label.

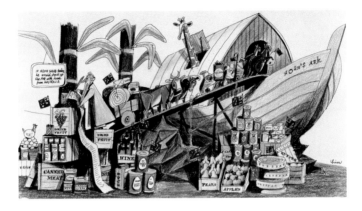

1960. George Him. 'Noah's Ark'. Pencil drawing for huge eventual display of Australian products at the Ideal Home Exhibition, Olympia. The animals entering the Ark are Australian and carry Australian produce.

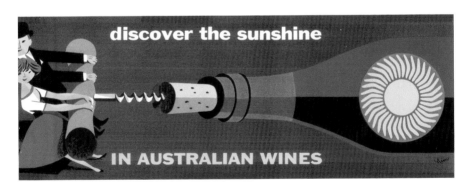

1962. George Him. 'Discover the sunshine in Australian wines'. Poster, bearing the Australian Trade Commission trademark, which was also designed by George Him.

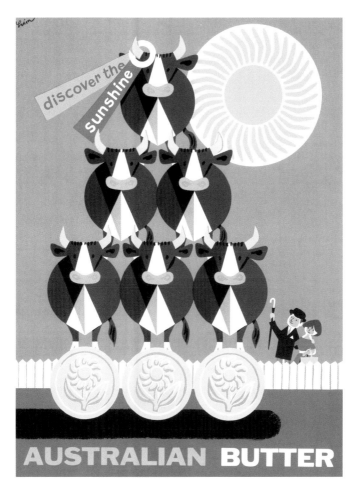

1962. George Him. 'Australian Butter'. Poster for the Australian Trade Commission.

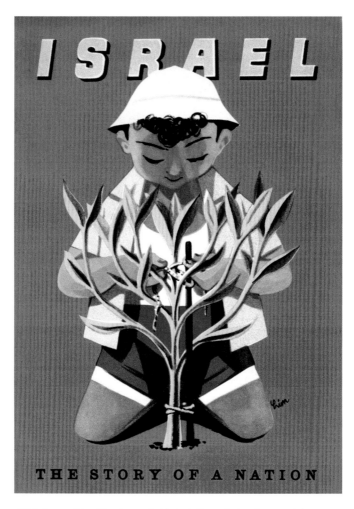

1958. George Him. 'The Story of a Nation'. Cover for booklet containing
illustrated text of Israeli Pavilion, Brussels Exposition 1958. Illustrations and text
by George Him.

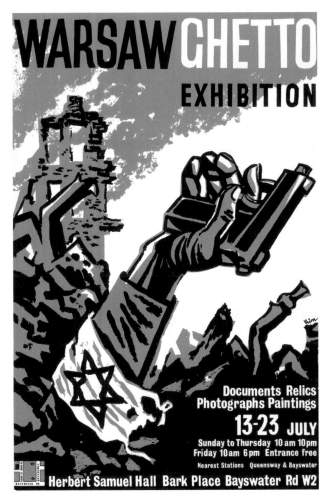

1961. George Him. Poster for Warsaw Ghetto Exhibition. The first exhibition in England on the subject of the Holocaust, "portraying by photographs, documents and relics the fate suffered by Polish Jewry under Nazi rule". The poster depicts the Warsaw Ghetto Uprising of 1943.

1965. George Him. 'London Tapestry'. Original design for mural for London office of El Al.

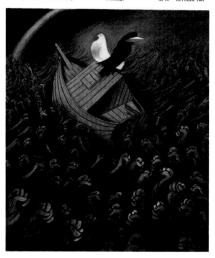

1969. George Him. 'Ocean of Hatred'. Cover for October edition of *New Middle East* magazine.

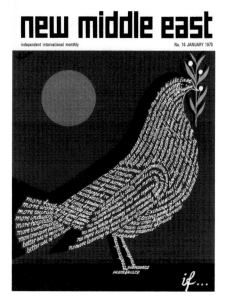

1970. George Him. 'if…' Cover for January edition of *New Middle East* magazine, "…started after the Arab-Israeli War of 1967 in the hope of creating a strictly non-partisan platform for a reasonable dialogue between the two warring parties which could eventually lead to a reconciliation and peace". – Him.

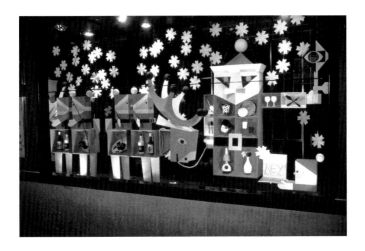

1960. George Him. Christmas window for the Design Centre in London. The rear of the display is open to disclose the interior of the building.

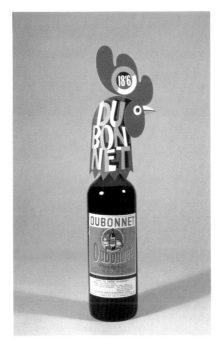

1962. George Him. Dubonnet Cock's Head Crowner.

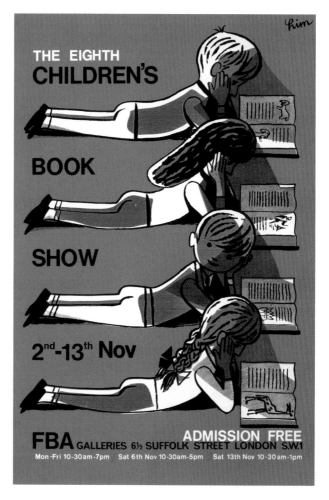

1970. George Him. Poster for the eighth 'Children's Book Show' at the Gallery of the Federation of British Artists.

George Him: Book Illustration

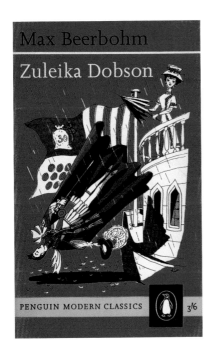

1961. George Him. Bookcover for *Zuleika Dobson* by Max Beerbohm for Penguin Books.

1966. George Him. Illustration for *Two Plays for Puritans* by George Bernard Shaw. The second of two illustrated books by George Him for George Macy of the Limited Editions Club, New York.

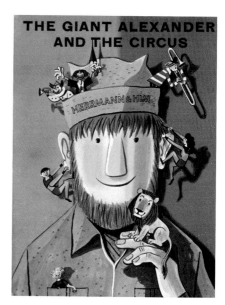

The Giant Alexander books by Frank Hermann and illustrated by George Him were published by Methuen (London), McGraw Hill (USA) and, finally, Puffin. They were also illustrated for the BBC. Him travelled to Maldon, the setting of the book, where he and Hermann agreed that the exact height of the Giant should be two telegraph poles. Left: 1964. Illustration from *The Giant Alexander*. Right: 1966. Front cover to *The Giant Alexander and the Circus*.

1974. George Him. Illustration (artwork), 'The Witch's Chair' from *King Midas* by Lynne Reid Banks, for the BBC's *Jackanory*, narrated by Michael Gough. The witch's cat is based on Percy, Him's family cat.

1979. George Him. Illustration (artwork), 'The Beginning of the Armadilloes' from *The Just So Stories* by Rudyard Kipling, for Thames Television, narrated by Frankie Howerd. At that time the Kipling Estate prohibited new illustrations for the book, but illustrations for film were permitted.

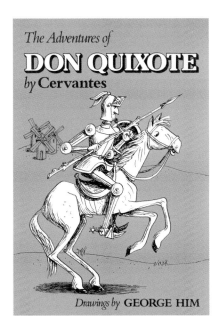

1980. George Him.
Bookcover (front and
back) for *The Adventures
of Don Quixote*, by
Cervantes, abridged by
Olive Jones, Methuen's
children's editor.

Text References

1. Lewitt is pronounced "Levitt" in Polish. When he first started working with Himmelfarb in Poland, he signed himself Levitt, pronounced "Lewitt" in Polish. Once in England he used the English pronunciation of his name, signing his design work as Lewitt, but calling himself Le Witt.

2. Early in his working partnership with Le Witt, Himmelfarb started signing work as 'Him'. "Lewitt-Himmelfarb was a bit of a mouthful", as he explained. When he was naturalised British in 1948, he officially changed his name from Jerzy Himmelfarb to George Him.

3. They set up a studio in Poland under the name Levitt-Him, on their move to England they signed their work Lewitt-Him.

4. Gasser, Manuel, 'Lewitt-Him' in *Graphis* 14, 1946, pp200-221.

5. de Holden Stone, James 'Pair of Aces' in *Art & Industry*, Sept. 1953, pp82-89.

6. 'Hyphenated Designers' in *Time Magazine*, 16 Nov., 1953, p1.

7. Carrington, Noel, 'British Poster Design During the War' in *Graphis* 14, 1946, pp172-185.

8. Tomrley, C.G., 'Lewitt-Him' in *Graphis* 48, 1953, pp268-275.

9. Mortimer, Raymond in *Design and Cultural Politics in Postwar Britain*, Maguire & Woodham, 1997, Leicester University Press, p57.

10. Gardner, James, 'The ARTful Designer', 1993, p135.

11. Sibley, Brian, *The Book of Guinness Advertising*, Guinness Books, 1985, pp115-119.

12. There is a tape recording of the clock working held in The Guinness Archives.

13. Barmas, John, 'Lewitt-Him versus Time' in *Art & Industry*, March 1952, pp93-95.

14. Him, George, 'Fat Person Singular', exhibition handout, 1976, London College of Printing.

15. Him, George, 'The Publicity Designer Today', paper read to AGI Conference, St. Germaine-en-Laye, 1960.

Look at this trio! Each one a glutton,
Eating sausages of partridge and mutton!

Chronology

1900	4 August, Jerzy Himmelfarb (George Him) born, Lodz, Poland
1907	3 April, Jan Lewitt (Le Witt) born, Czestochowa, Poland
1920-24	Himmelfarb studies for first degree, awarded PhD from Bonn University
1924-28	Himmelfarb studies at Leipzig Academy for Graphic Art and the Book Industry
1925-28	Lewitt travels around Europe and the Middle East
1928	Lewitt starts working as graphic designer in Poland
1928-32	Himmelfarb works as graphic designer in Germany
1930	Lewitt Exhibition at Society of Fine Art, Warsaw
1931	Lewitt spends year in Paris
1933	January, Himmelfarb exhibition of pictures at Winter Salon, Warsaw
1933	Lewitt and Himmelfarb partnership formed: Studio "Levitt-Him", Warsaw. (From this point on Himmelfarb shortens his signature to Him, he later also adopts this as his surname.) Work includes: covers for *Skamander* Magazine; illustrations for *Wiadomosci Literackie* (Literary News); advertisements for medical pamphlets; publicity for Jabikowski Brothers
1937	October, Lewitt and Him arrive in London. (Outside the partnership and in his personal life Lewitt adopts the style Le Witt). They set up Studio "Lewitt-Him" London exhibition at Lund Humphries.
1938	Julian Tuwim's *Lokomotywa* published, illustrated by Levitt-Him
1939	*Football's Revolt* published by *Country Life*, written and illustrated by Lewitt-Him. English and French editions of Tuwim's *Lokomotywa* published
1939	Jan Le Witt marries Alina Prusicka
1939-45	Lewitt-Him partnership produces wartime posters for Ministry of Information, Ministry of Food, Ministry of War Transport, Post Office etc; books, pamphlets and posters for the Dutch and Polish Governments in exile.
1940	*Poland's Martyrdom*, the German invasion presented in photographs and facts, compiled by Lewitt-Him (Kolin)
1941	*Polish Panorama*, written and illustrated by Lewitt-Him (Kolin)
1942	*The Little Red Engine Gets A Name* by Diana Ross, illustrated by Lewitt-Him (Faber)
1943	*Blue Peter* by Alina Lewitt, illustrated by Lewitt-Him (Faber)
1944	*Five Silly Cats* by Alina Lewitt, illustrated by Lewitt-Him (Minerva)
1945	Alina and Jan Le Witt's son, Michael is born
1946	'Britain Can Make It' Exhibition
1947	Le Witt naturalised British
	Lewitt-Him partnership produces work for American Overseas Airlines
	Le Witt has first solo exhibition, Zwemmer's Art Gallery
1948	Him naturalised British
	Lewitt-Him Exhibition in Stockholm
	Diploma for Lewitt-Him at International Poster Exhibition
1949	Le Witt designs scenery and costumes for the Sadler's Wells production of Debussy's *Children's Corner*
1951	Lewitt-Him partnership designs the Guinness Festival Clock for Festival of Britain
	AGI first AGM. English elected members: Eckersley, Friedman, Gray, Havinden, Henrion, Keely, Le Witt, Him and Schleger

1951-64 Lewitt-Him partnership, then Him alone, work with Stephen Potter on 'Schweppshire' advertisements

1953 Lewitt-Him partnership designs Enkalon stand for the Rayon Textile Exhibition, the Netherlands

Lewitt-Him work shown at Associated American Artists Galleries, New York

Le Witt exhibition, Zwemmer's Art Gallery

1955 1 January, Lewitt-Him partnership dissolved. Him continues to produce designs for clients such as Schweppes, Australia House and Philips, as well as illustrations for books and television graphics. Le Witt focuses on painting.

First exhibition of the Alliance Graphique Internationale, the Louvre, Paris

1957 Le Witt exhibition, Gallery Apollinaire, Milan

1958 Him illustrates "For Better For Worse", animated film for Halas and Batchelor, Brussels Expo

1960 Le Witt exhibition, Gallery Lacloche, Paris

1960 Him appointed El Al chief designer; designs Penguin book covers; illustrates Beerbohm's *Zuleika Dobson*

1961 Him made honorary designer for 'Warsaw Ghetto' exhibition

Le Witt exhibition, Grosvenor Gallery, London

1963 Le Witt exhibition, Gallery Lacloche, Paris

1964-75 Him illustrates *Giant Alexander* books by Frank Herrmann (Methuen)

1965 Le Witt exhibition, Musée d'Antibes

1966 Him conceives/designs 'Masada' exhibition, Festival Hall, London;

exhibition then travels to USA, France, Germany, Holland, Belgium, Sweden, Switzerland and Israel

Him illustrates Shaw's *Two Plays for Puritans*

Him illustrates *Folk Tales* by Leila Berg (Brockhampton)

1967 Retrospective of Le Witt's art, Museum of Modern Art, Warsaw

Him appointed chief designer of Israel Pavilion, Expo 67 Montreal

1968 George Him marries Shirley Elizabeth Harman (née Rhodes)

1968-71 Him designs covers for *New Middle East* magazines

1969 Him illustrates *The Day with the Duke* by Ann Thwaite (Brockhampton)

1969-77 Him is Senior Lecturer in Design, Leicester Polytechnic

1970 Routledge publishes monograph *Jan Le Witt* by Sir Herbert Read, Jean Casson and John Smith

Le Witt exhibition, Sala Napoleonoca, Venice

1974-76 Him illustrates the *King Wilbur* books by Jim Rogerson (Dent)

1976 Him illustrates *King Midas* by Lynn Reid Banks (Dent)

1977 Him designs posters and logo for National Children's Book Week

Him elected Royal Designer for Industry

1980 Him illustrates *Don Quixote* by Cervantes (Methuen)

1981 Him illustrates *For Jerusalem and All Her People* for the Jerusalem Foundation

1982 George Him dies

1989 Le Witt exhibition, Fitzwilliam Museum, Cambridge

1991 Jan Le Witt dies

Selected bibliography and reference material

Central Office of Information, *Persuading the People, Government Publicity in the Second World War*, 1995, H.M.S.O.

Him, George, 'Cabbages and Kings' in *Art & Industry*, July 1955, pp18-21.

Read, Sir Herbert, *et al*, *Jan Le Witt*, 1971, Routledge & Kegan Paul.

Rosner, Charles, 'George Him' in *Graphis* 94, 1961, pp146-155.

unsigned, 'Lewitt-Him – a collaboration of ideals and ideas' in *Art & Industry*, Aug. 1942, pp38-41.

V&A Art Archives – George Him Archives

Williams-Ellis, Amabel, 'Lewitt-Him and the use of Nonsense' in *Art & Industry*, April 1947, pp104-111.

www.georgehim.co.uk

Zulawski, Marek, 'George Him's Art' in *The Jewish Quarterly*, vol.24, Autumn 1976.

This is the fly
responsible for
the crash

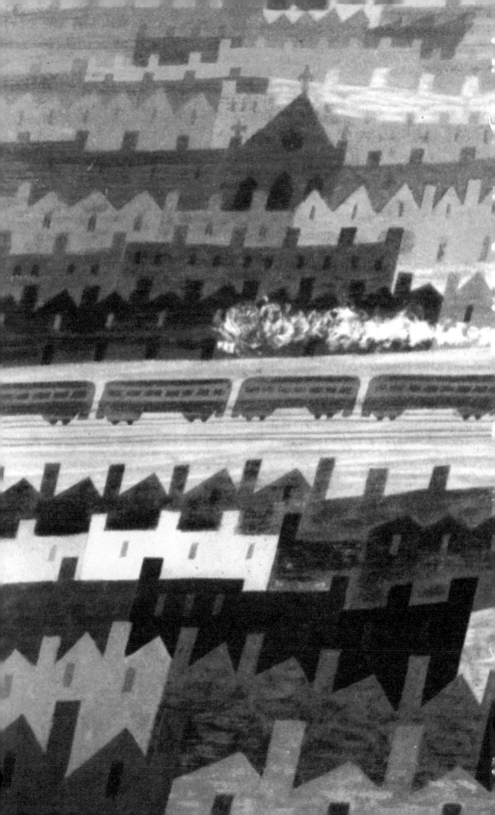